DEDICATED TO MY LITTLE SISTER
WHO LOVES TO PAINT

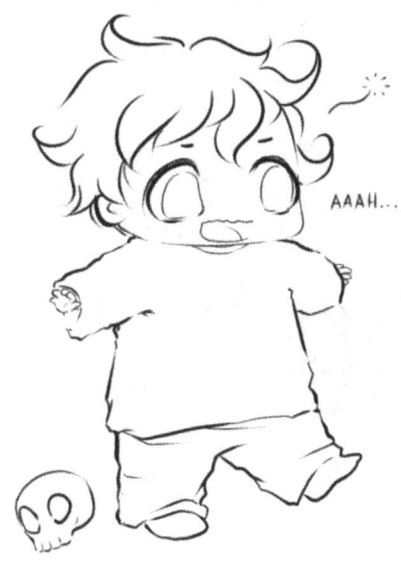

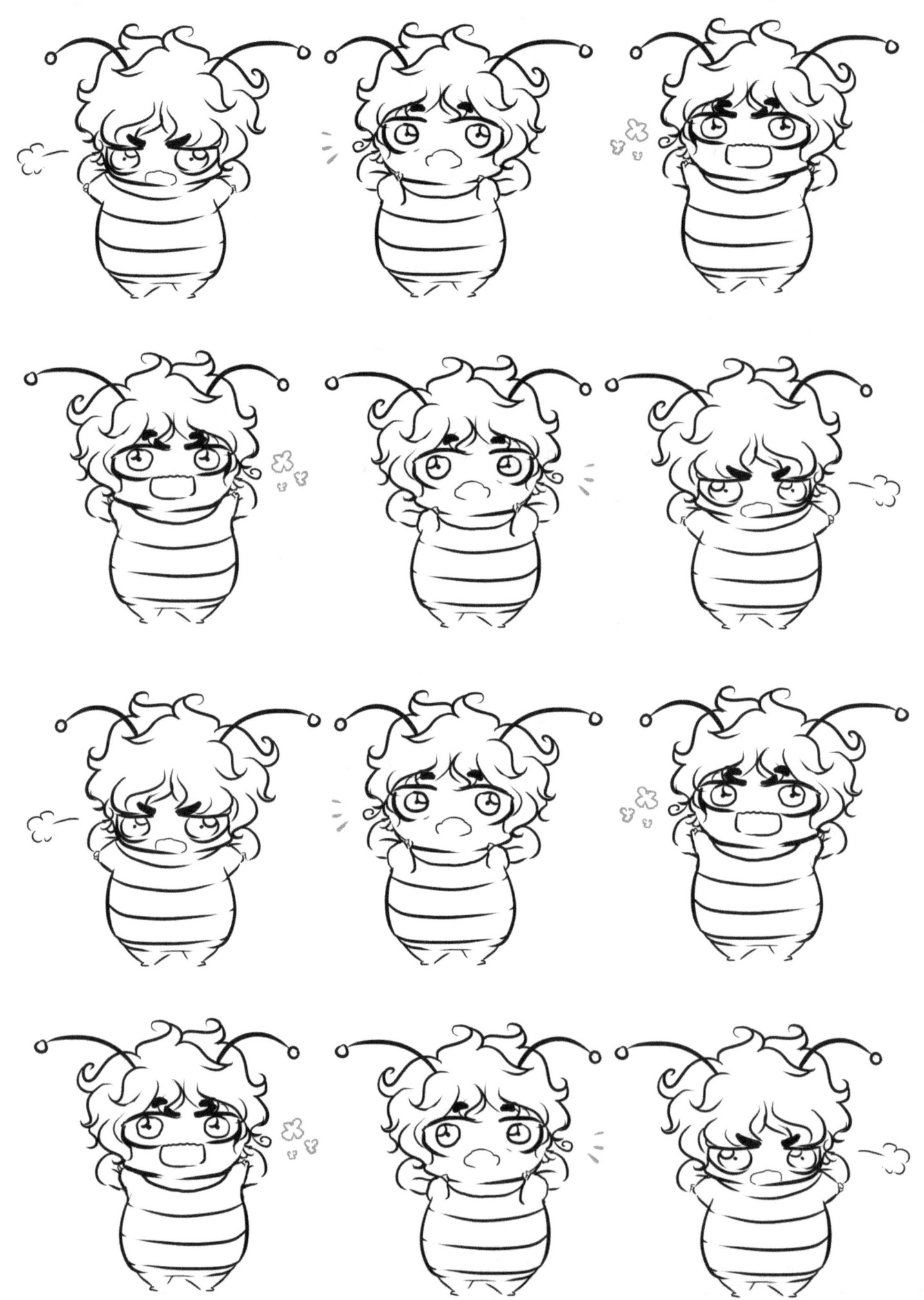

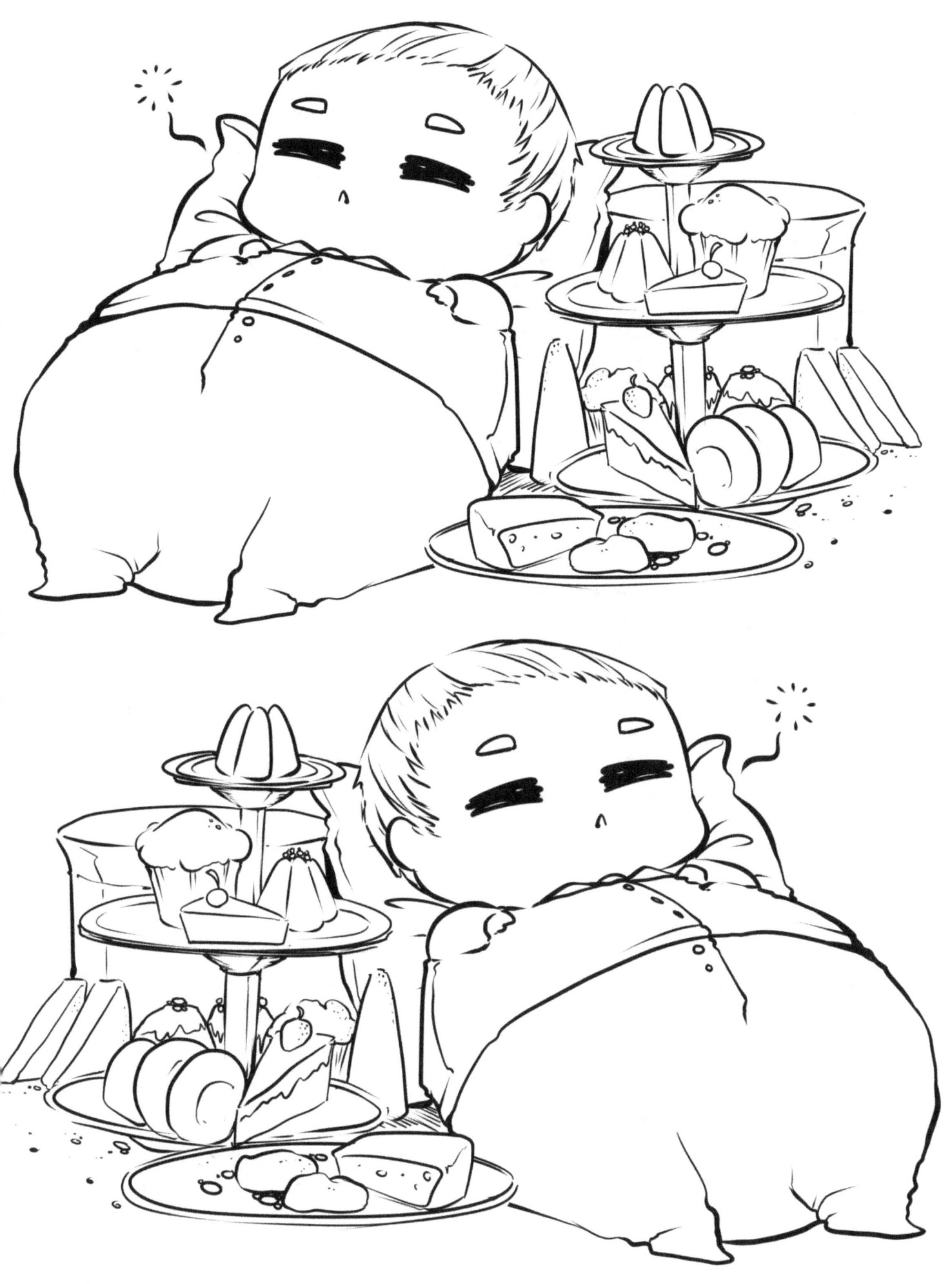

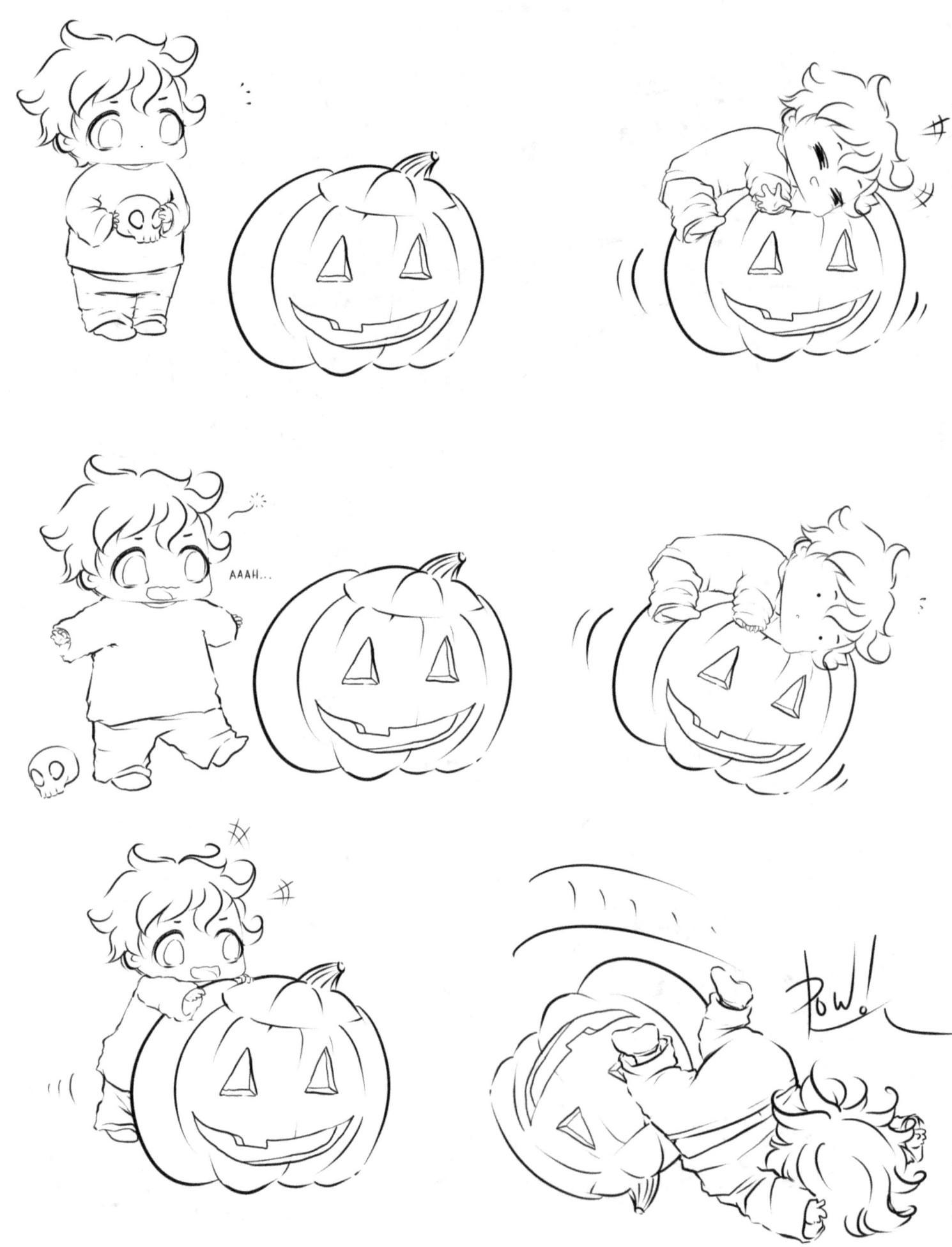

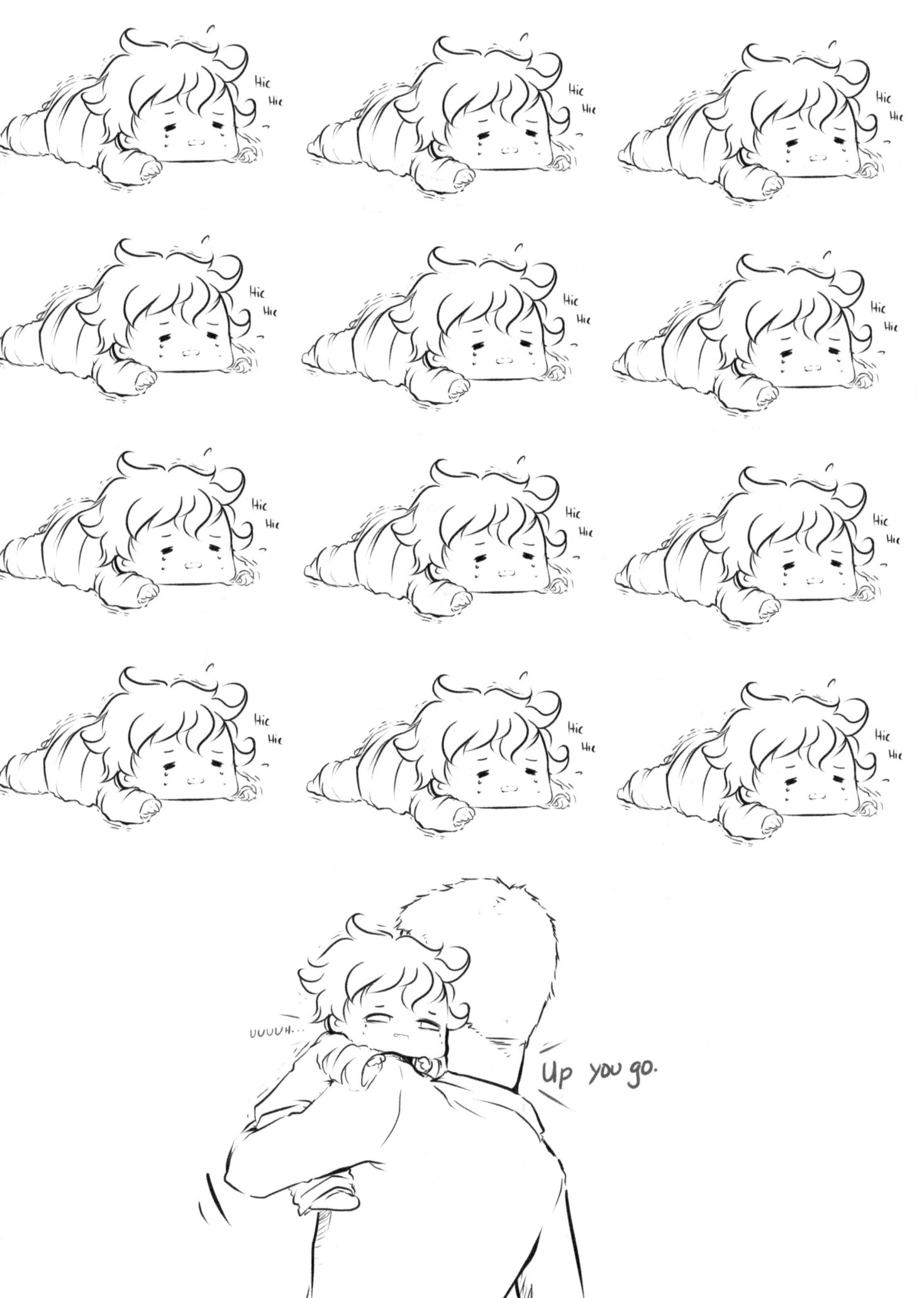

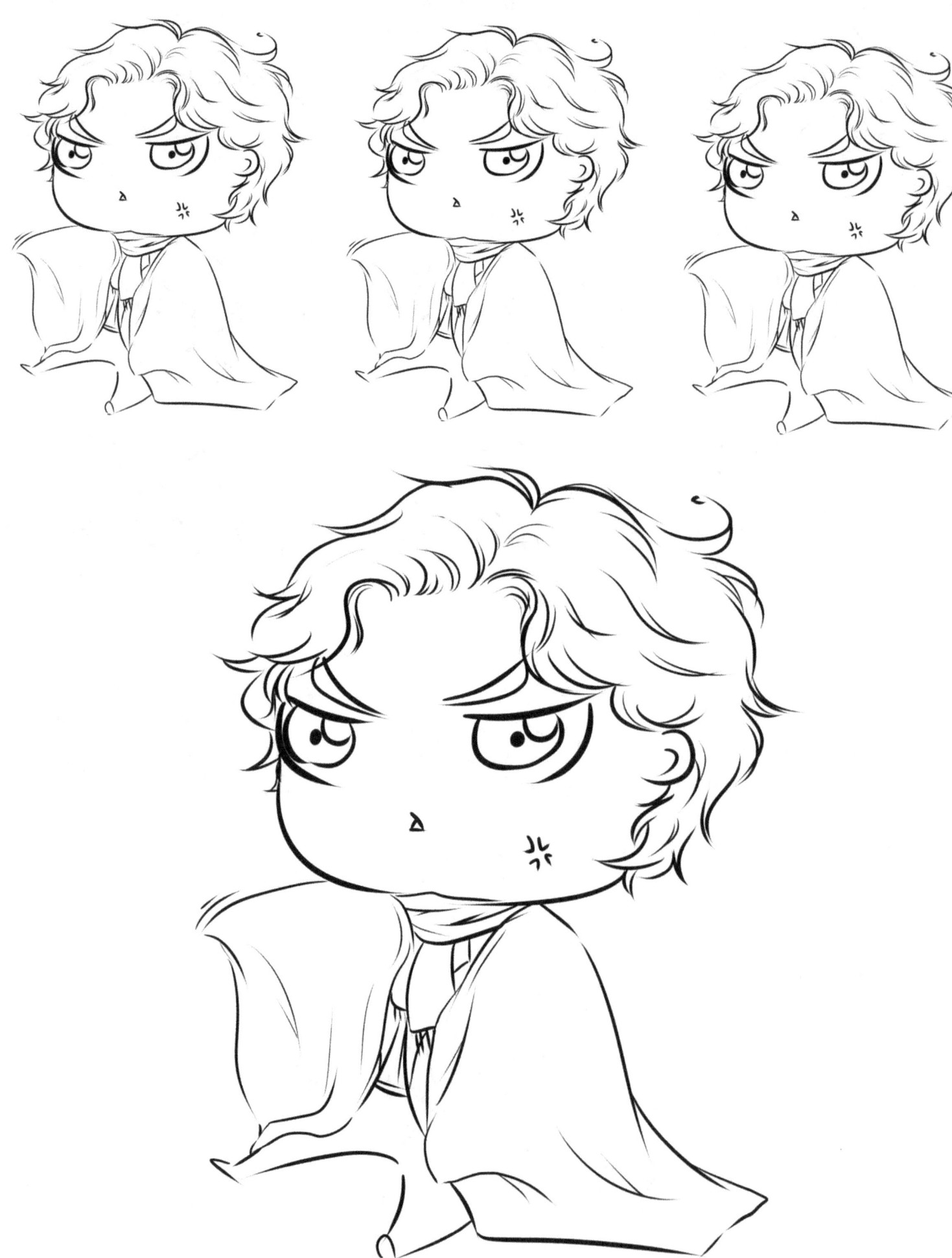

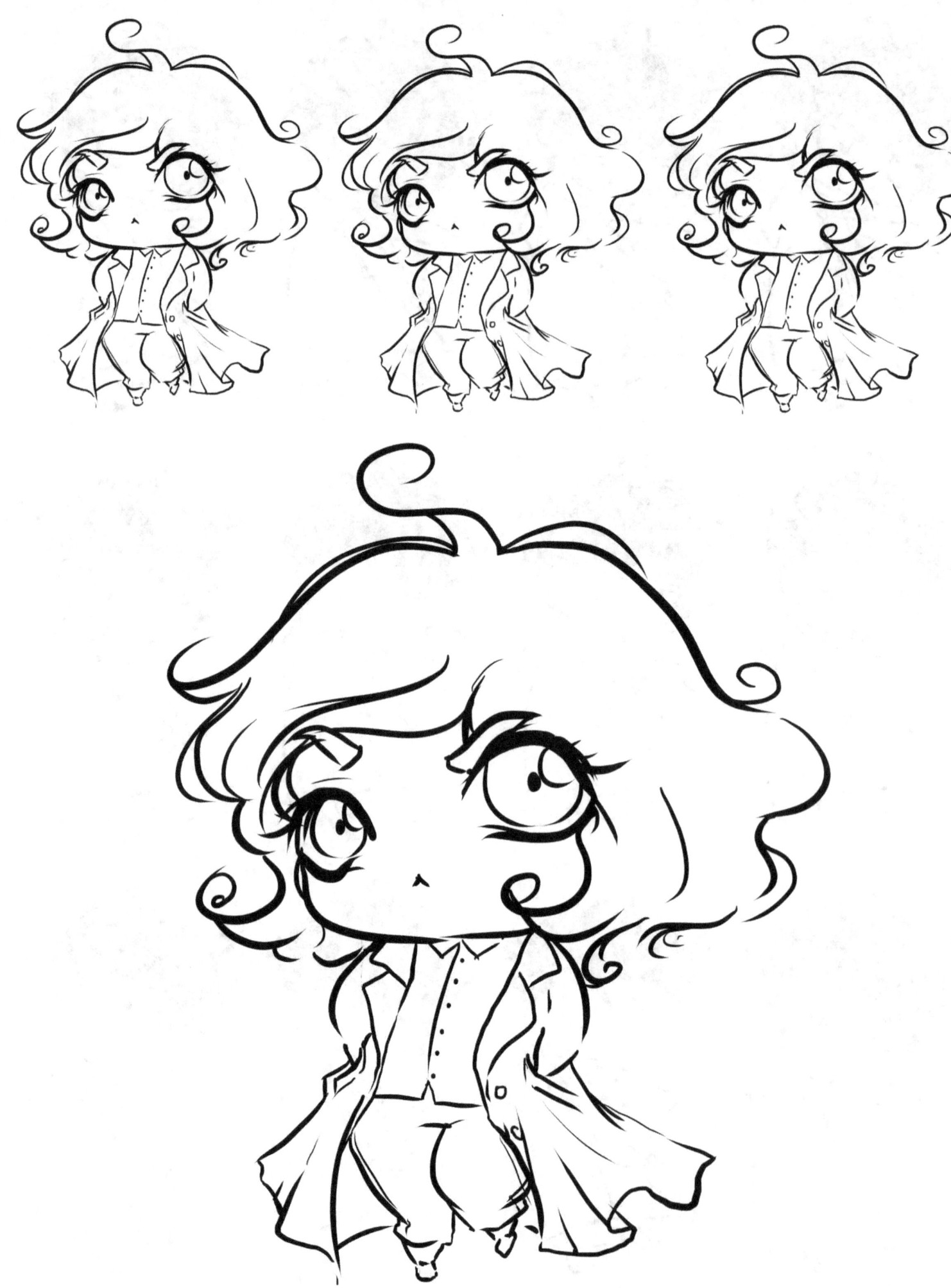

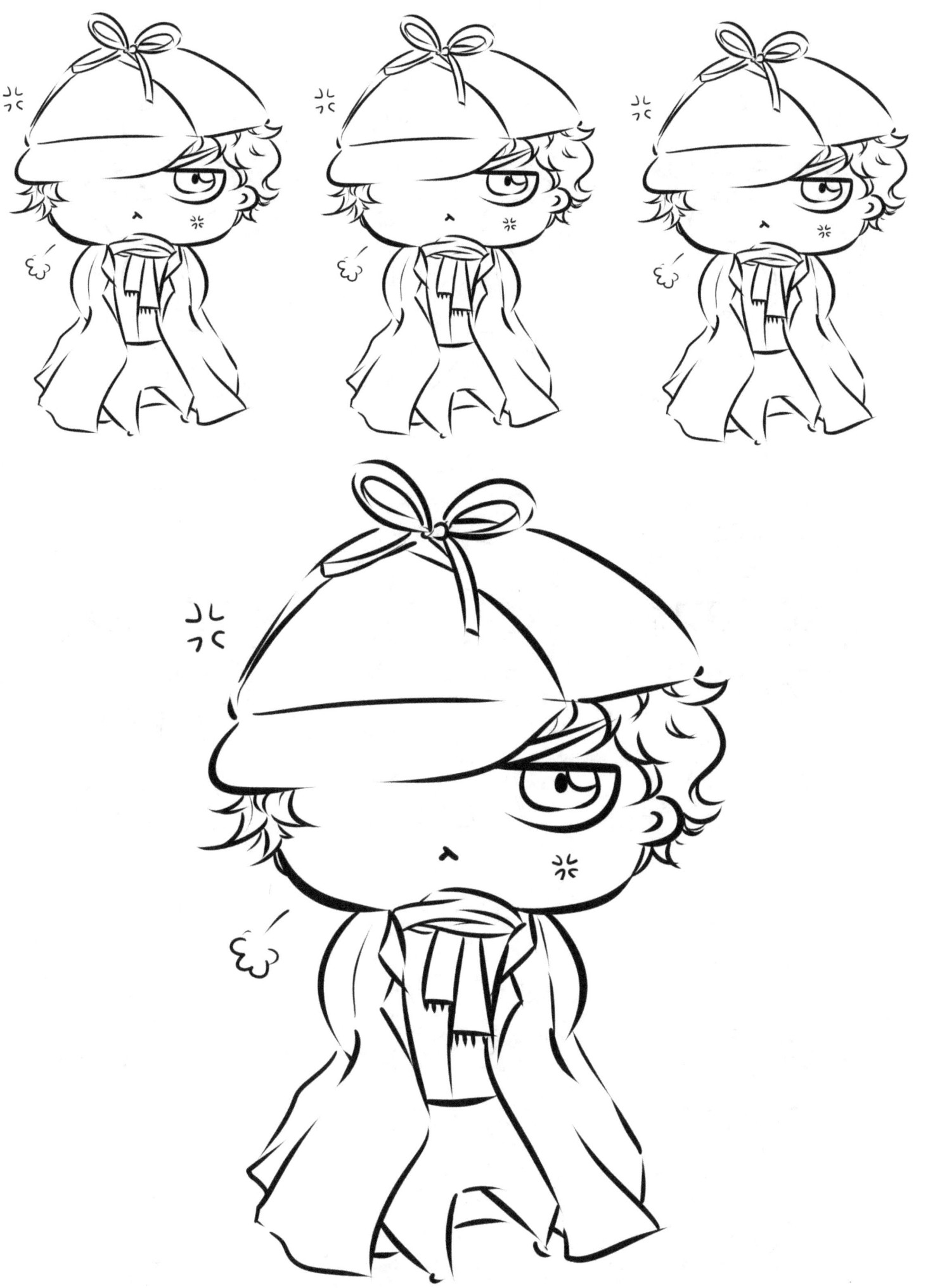

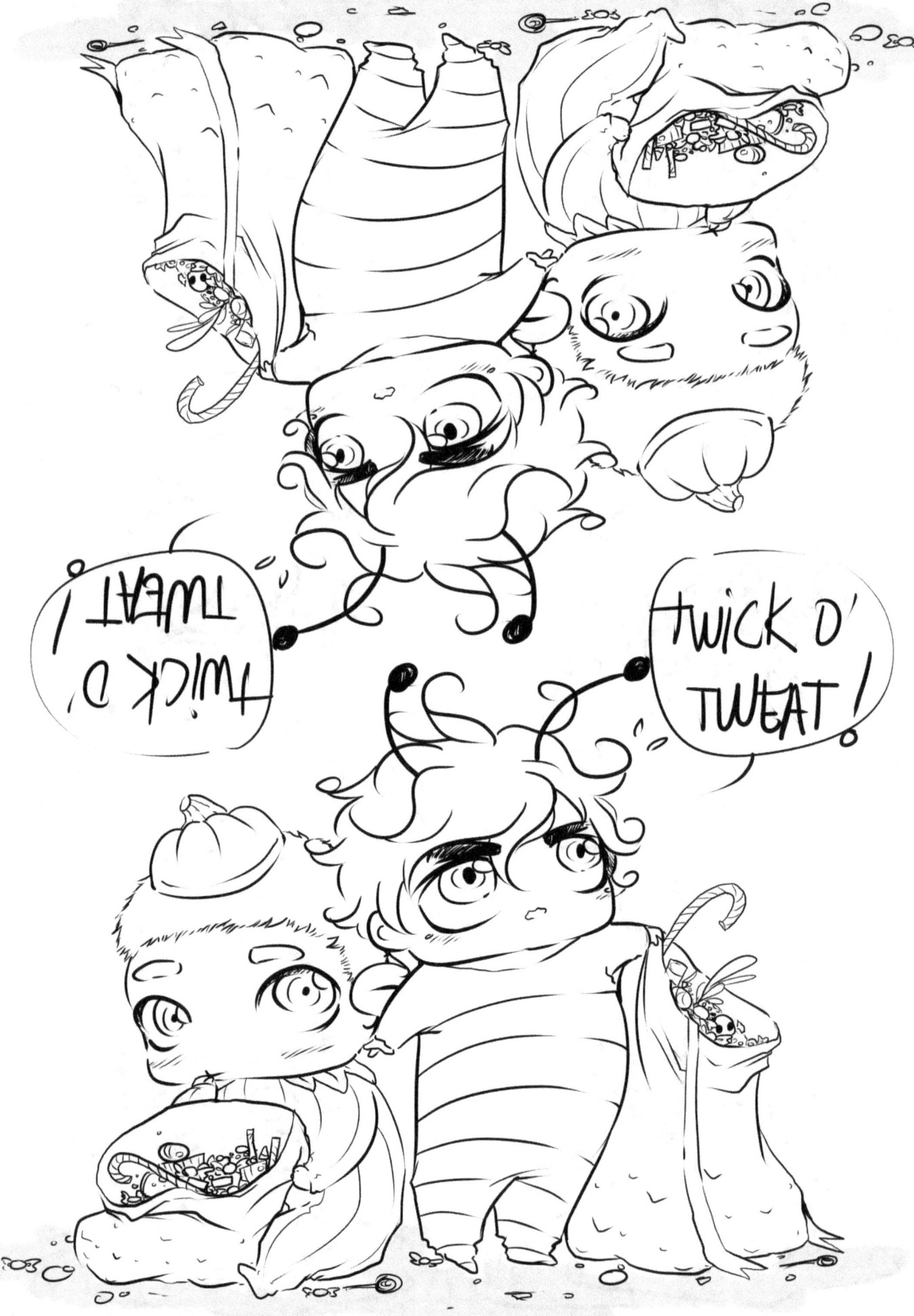

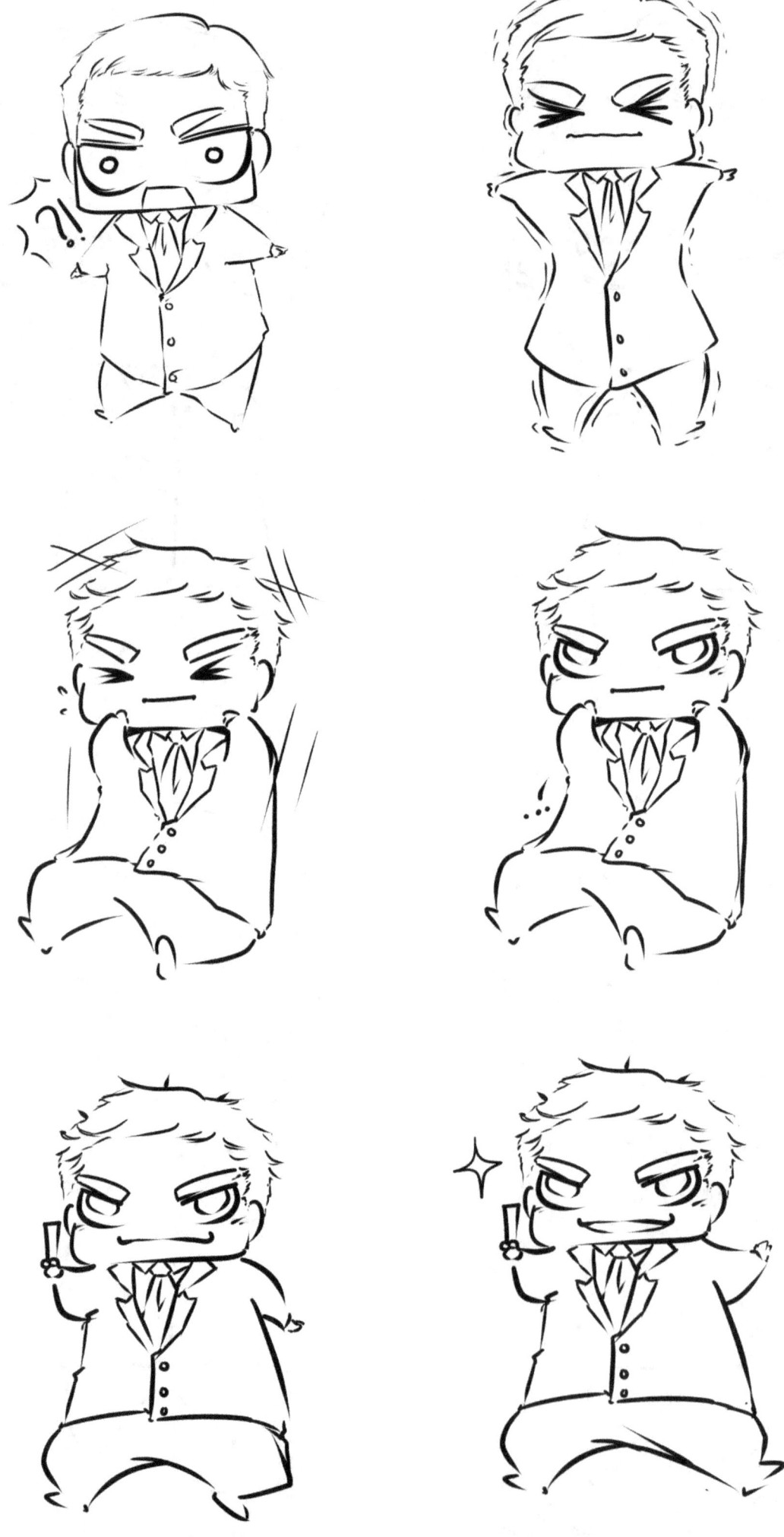

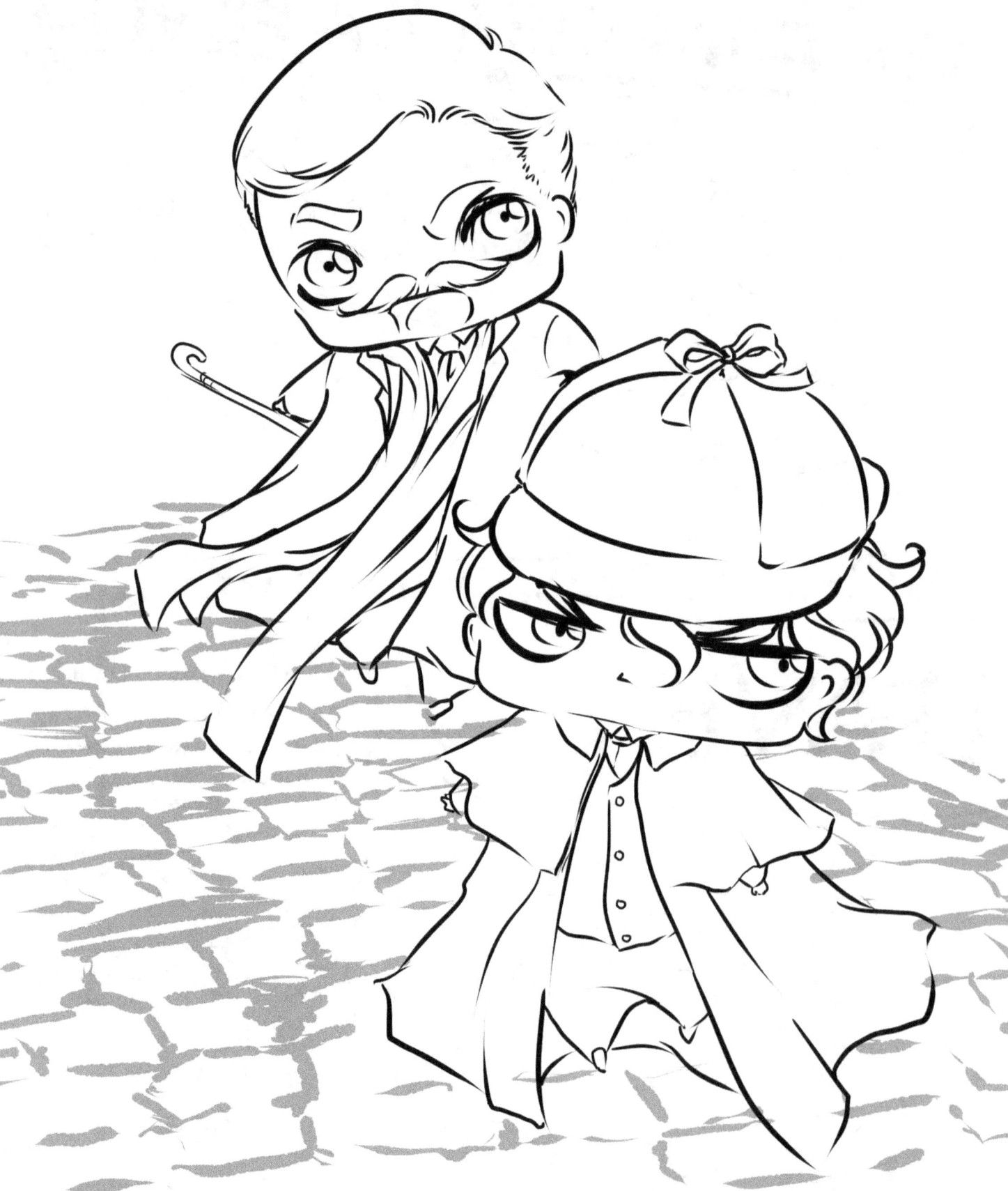

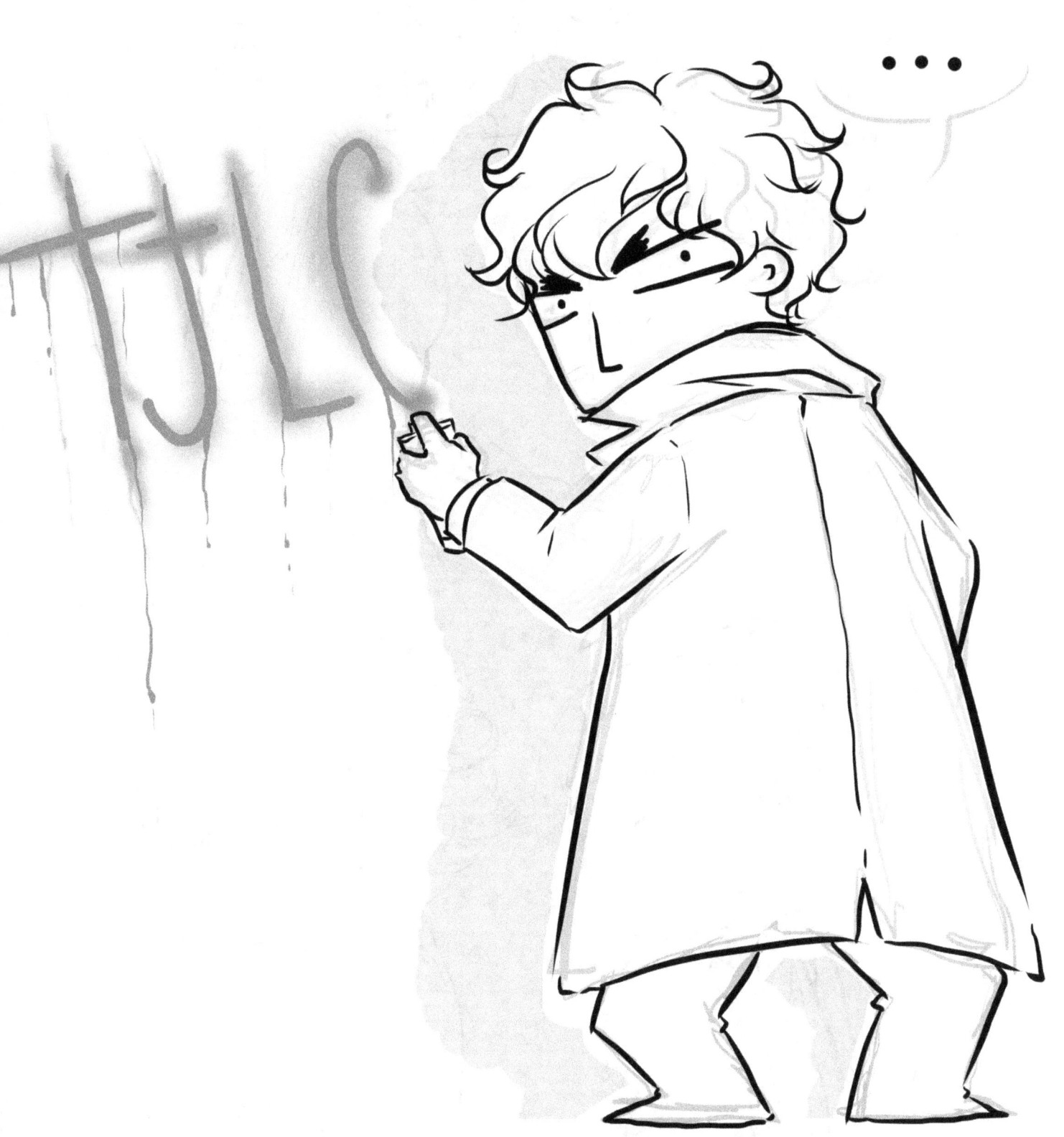

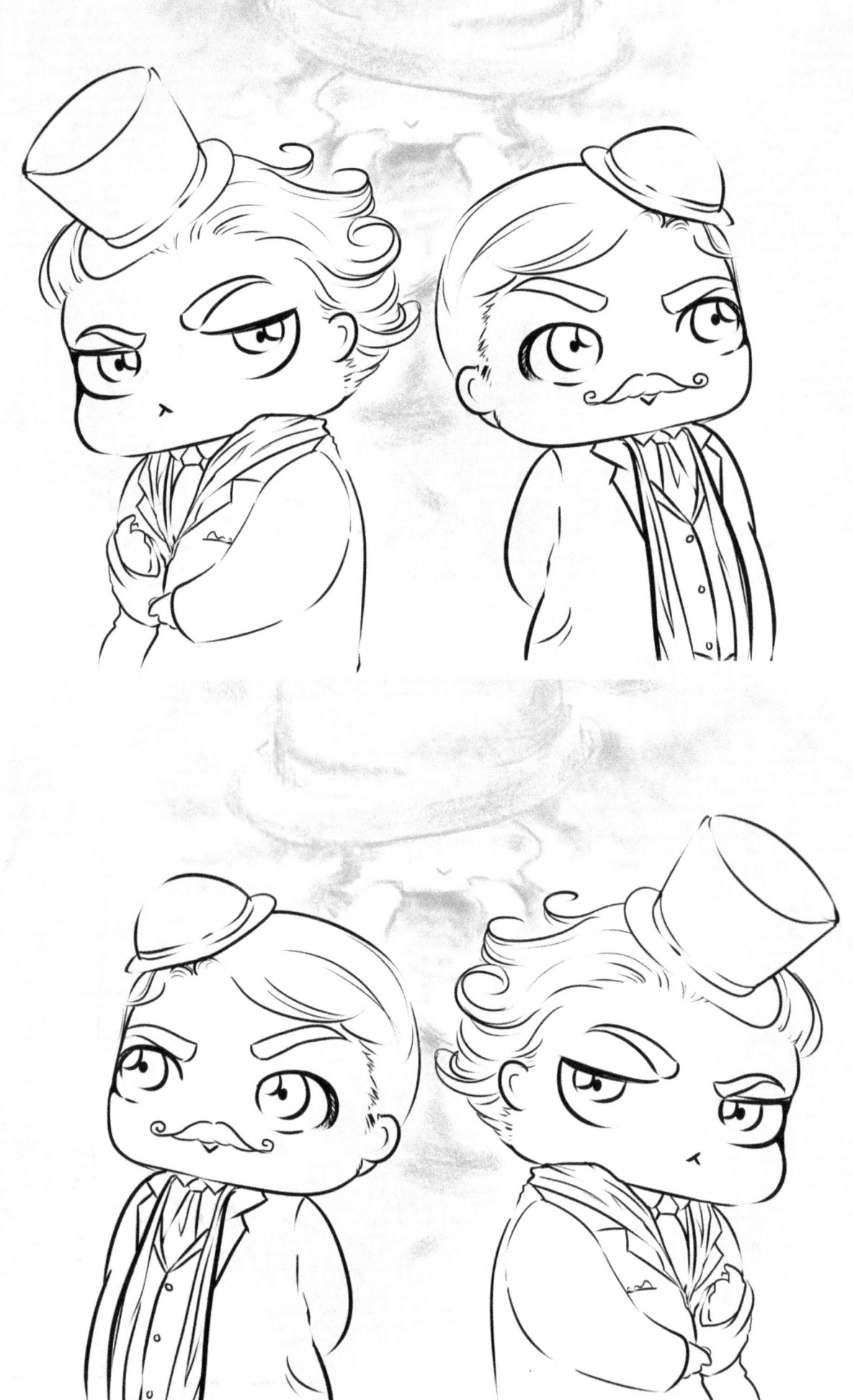

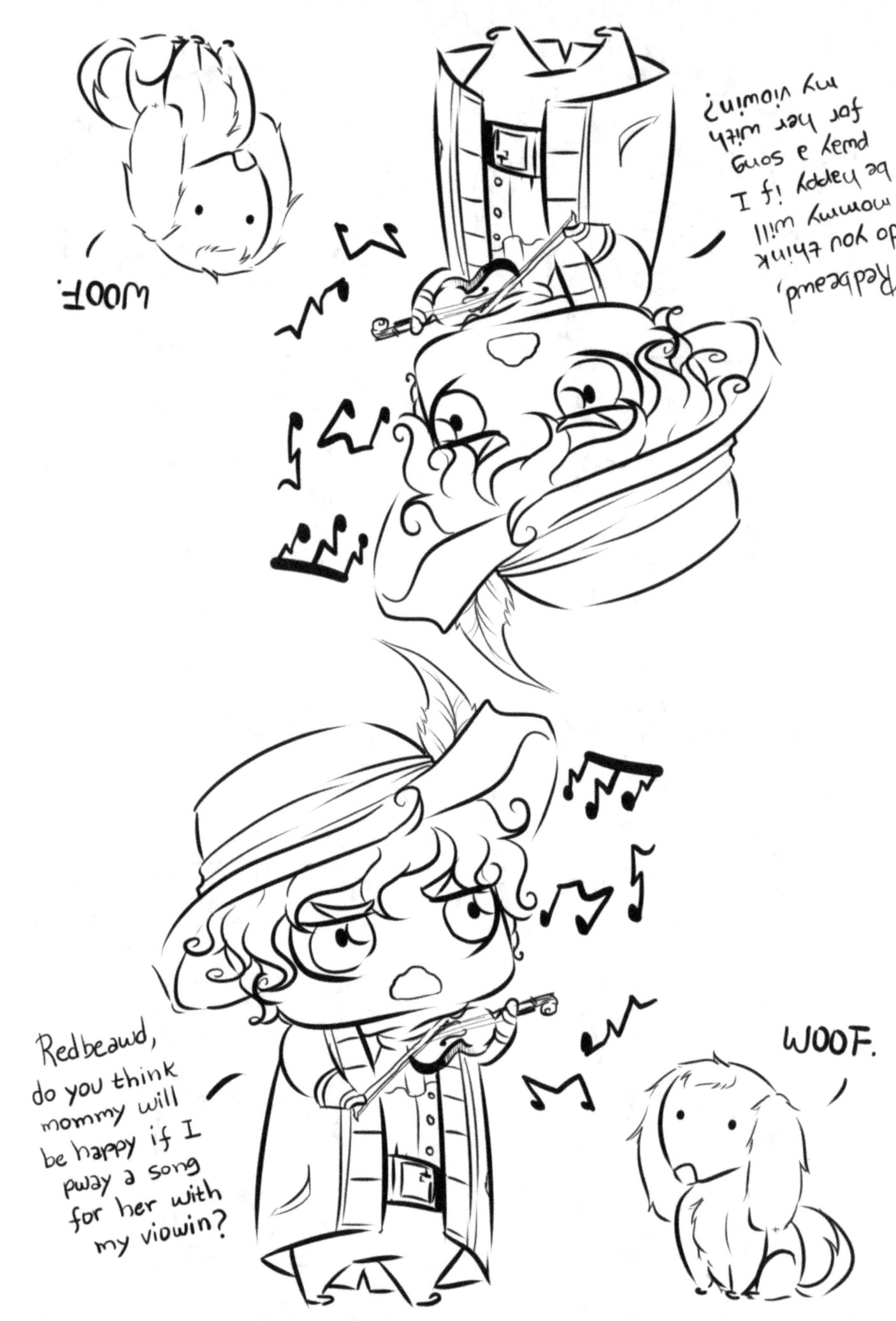

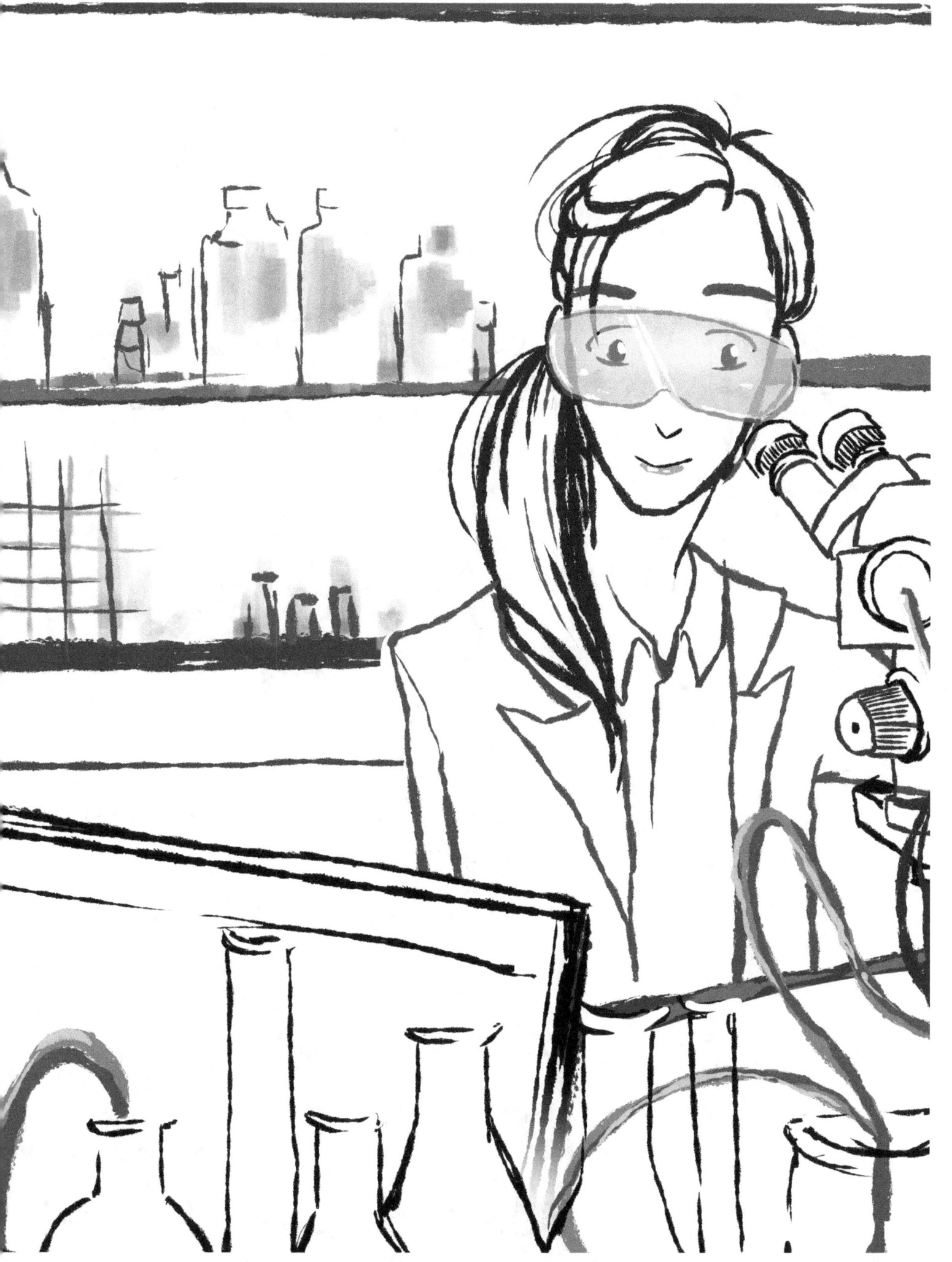

SHERLOCK